Epic Skull Adult Coloring Book

By Susan Potterfields

Copyright © 2016 Susan Potterfields

All rights reserved.

ISBN: 10: 1539501892
ISBN- 13: 978-1539501893

How would you like to be able to print off copies of your favorite coloring books?

How about having access to over a 1000's coloring books for the price of one coloring book every month.

Coupon Code to Join for only $1.00 for the first month when you sign up for the mailing list.

TRYTODAY

www.digitalcoloringbooks.com

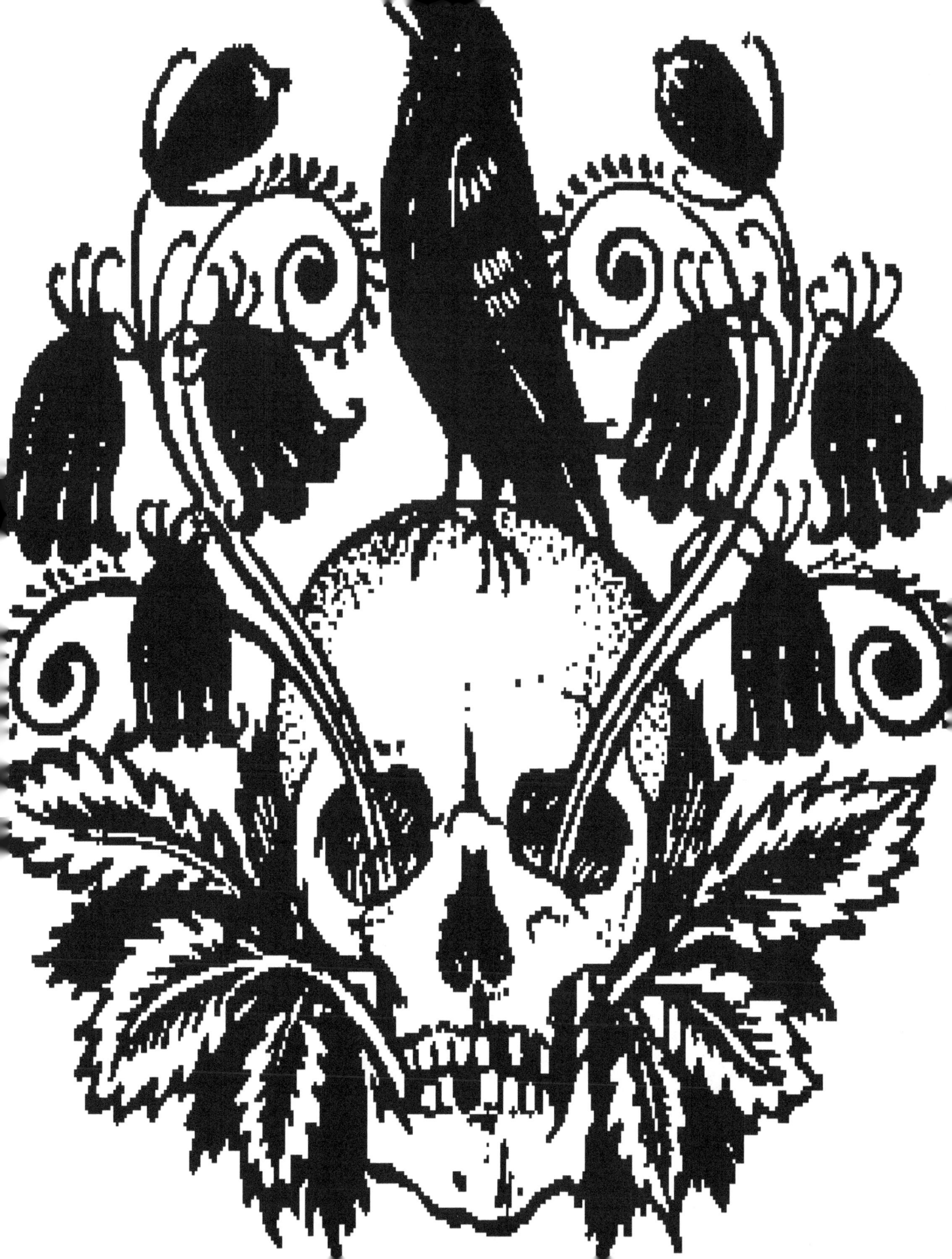

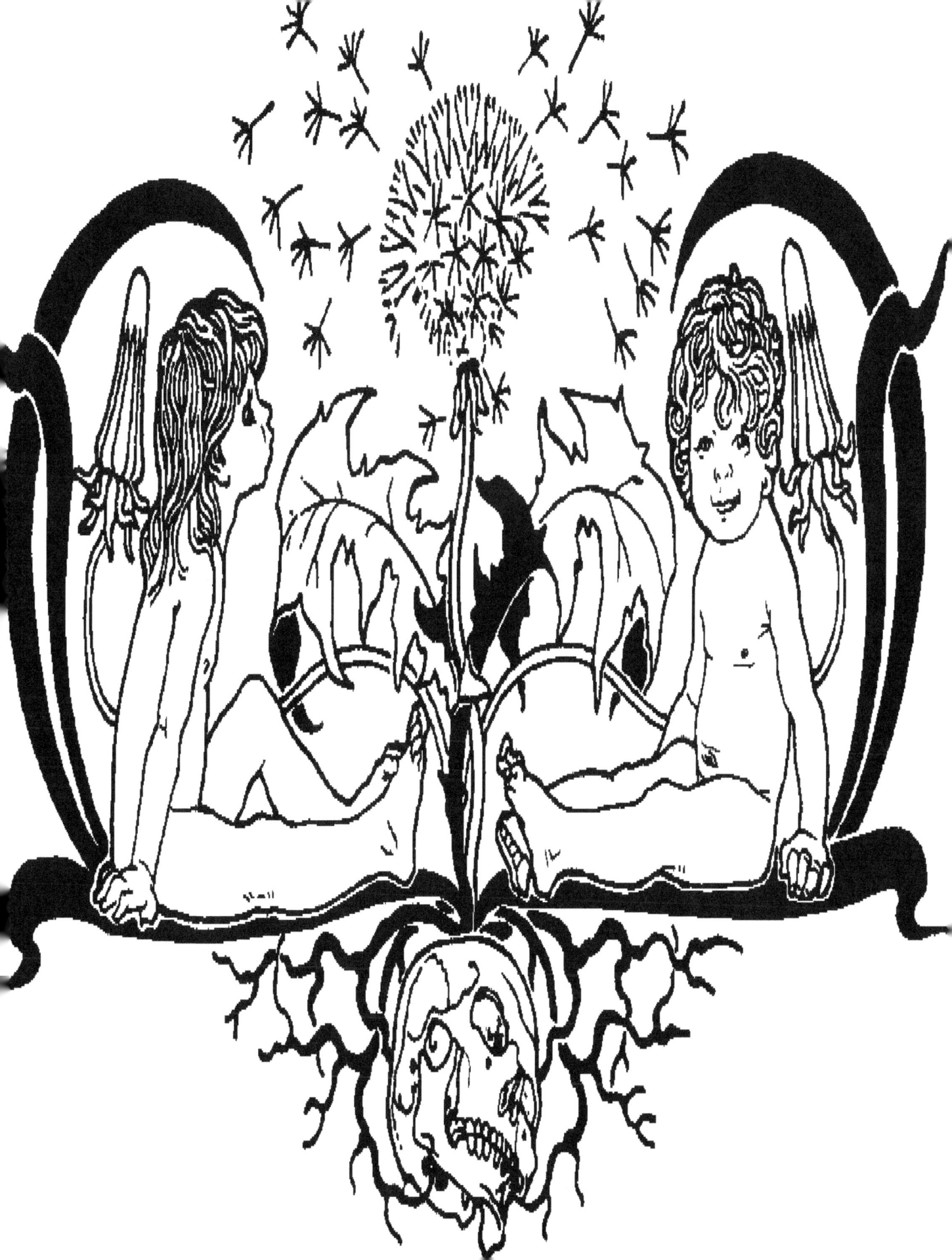

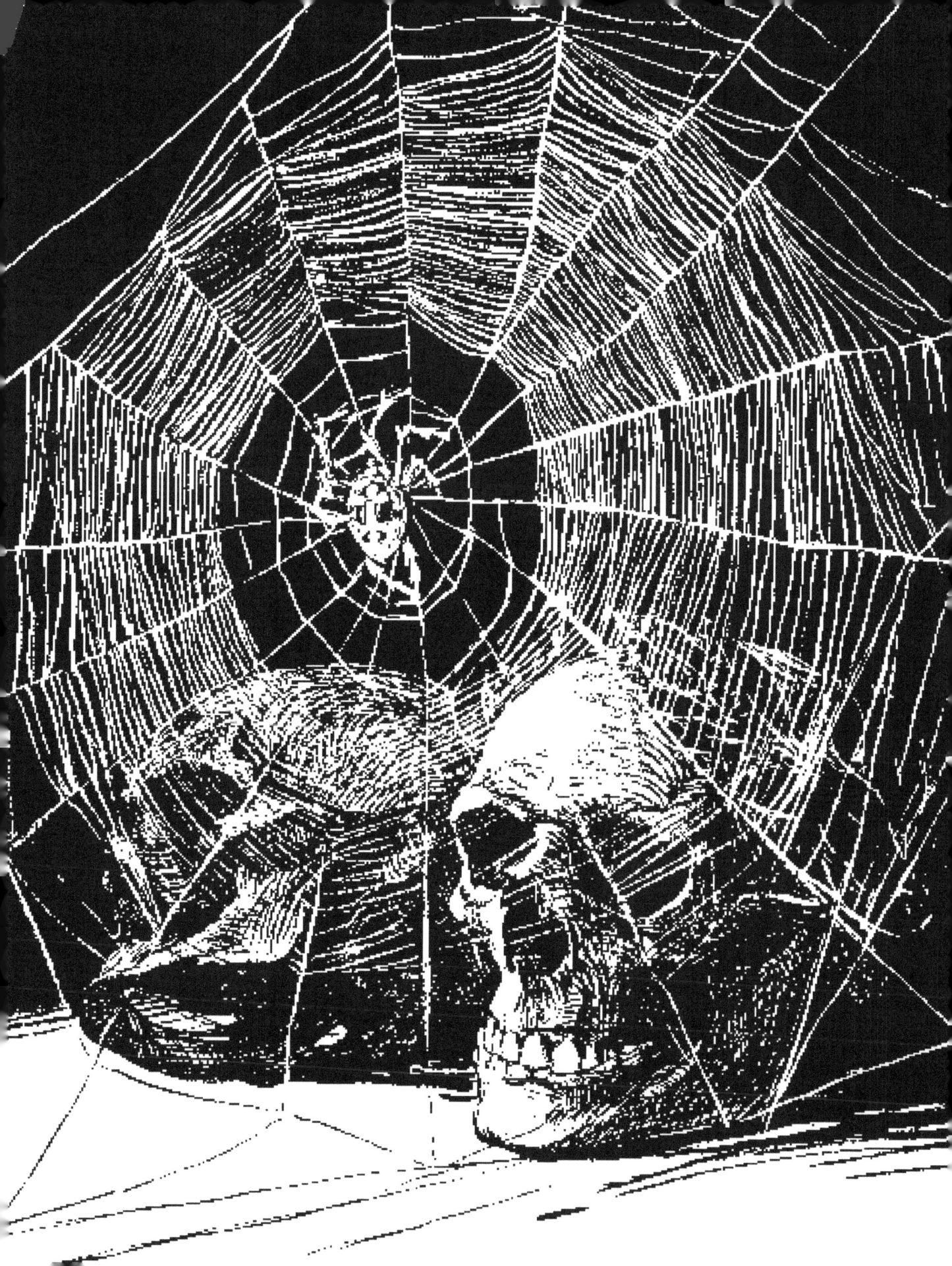

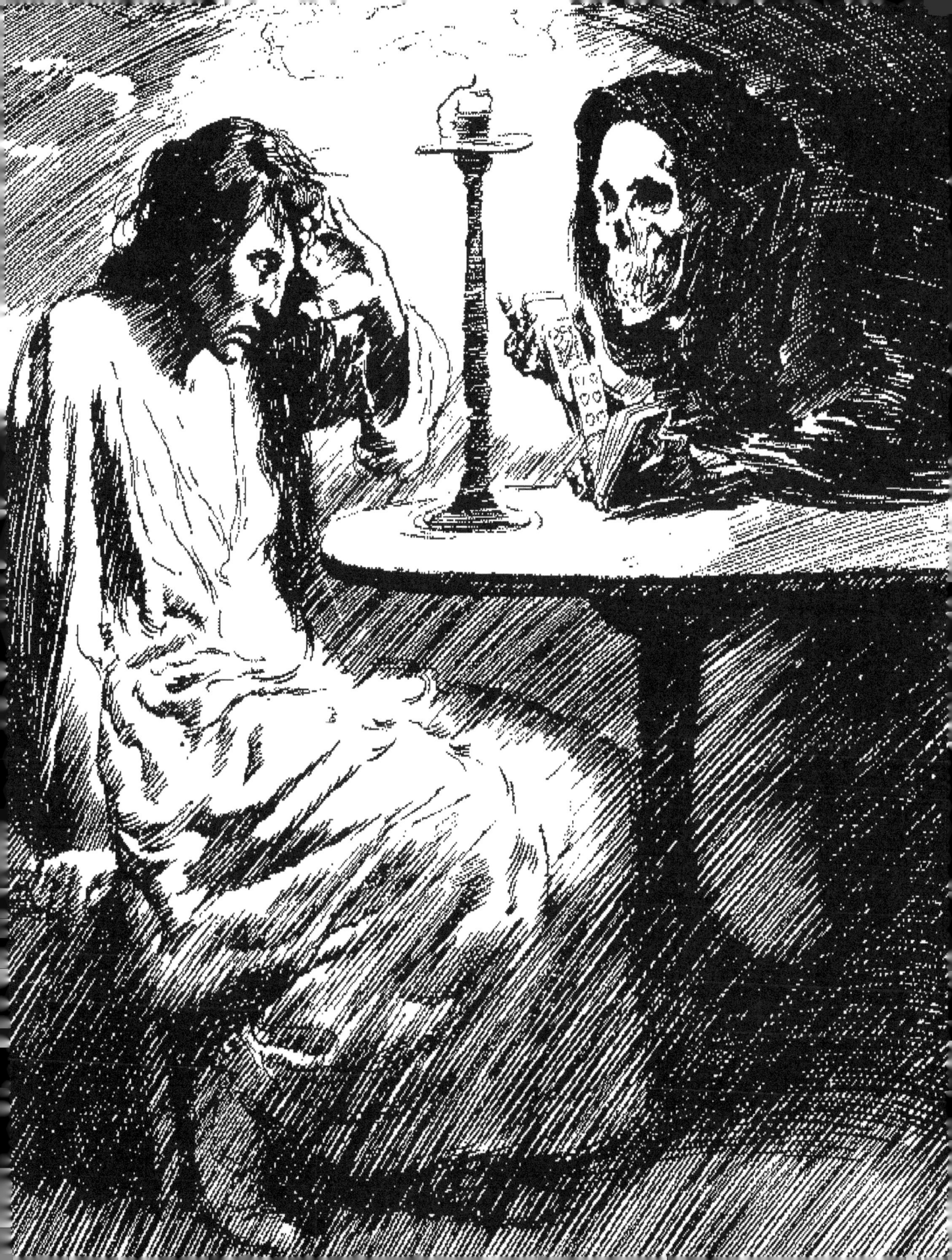

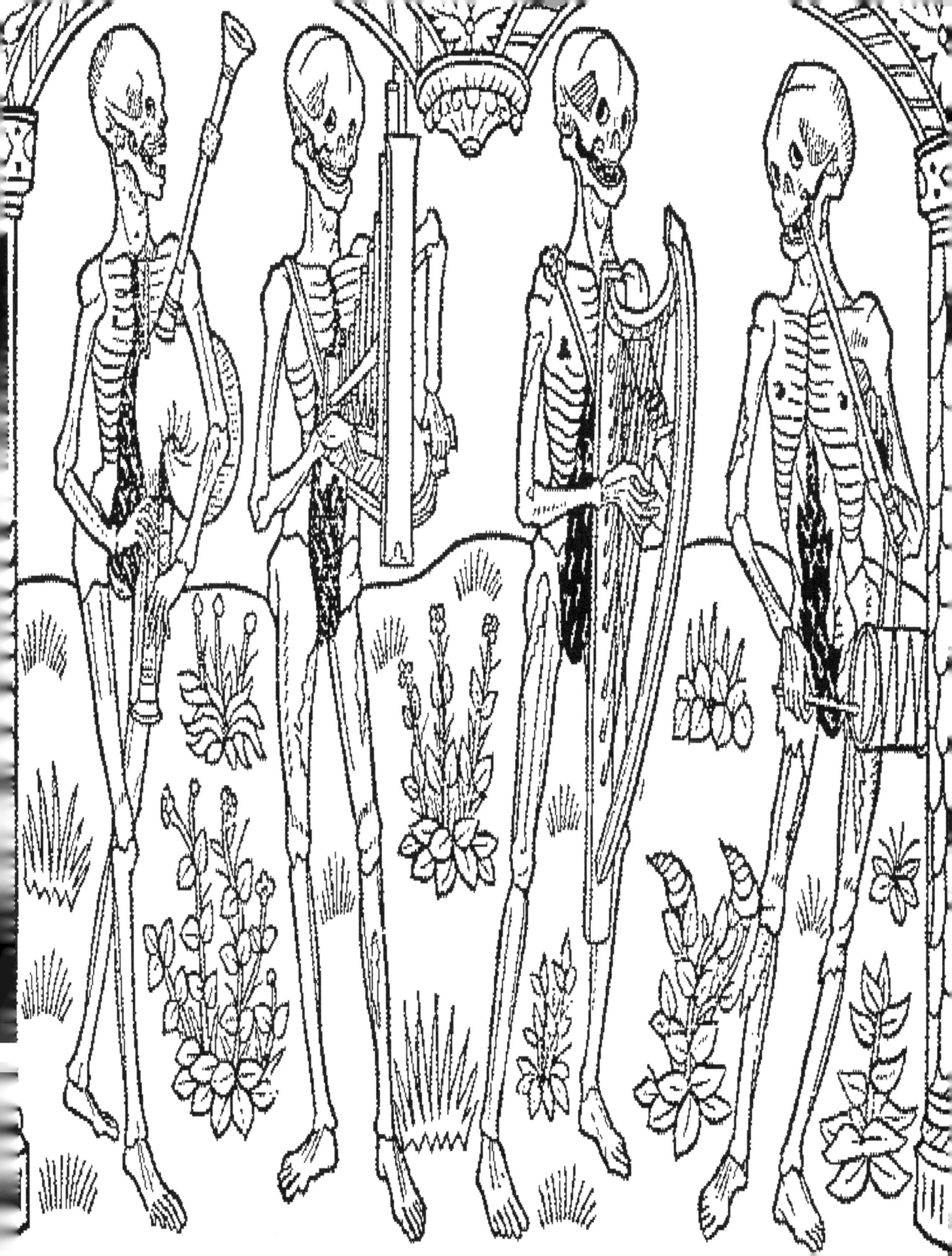

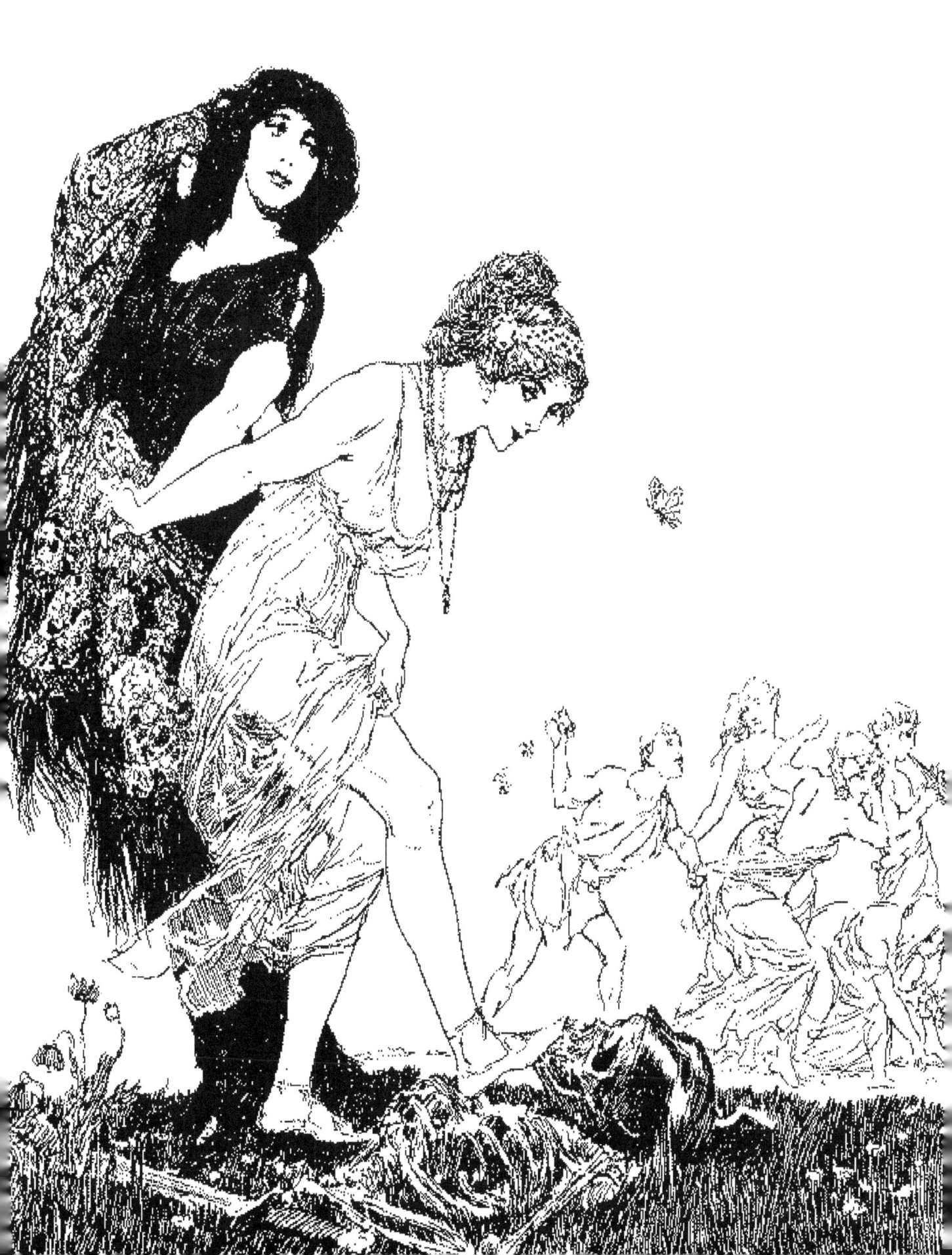

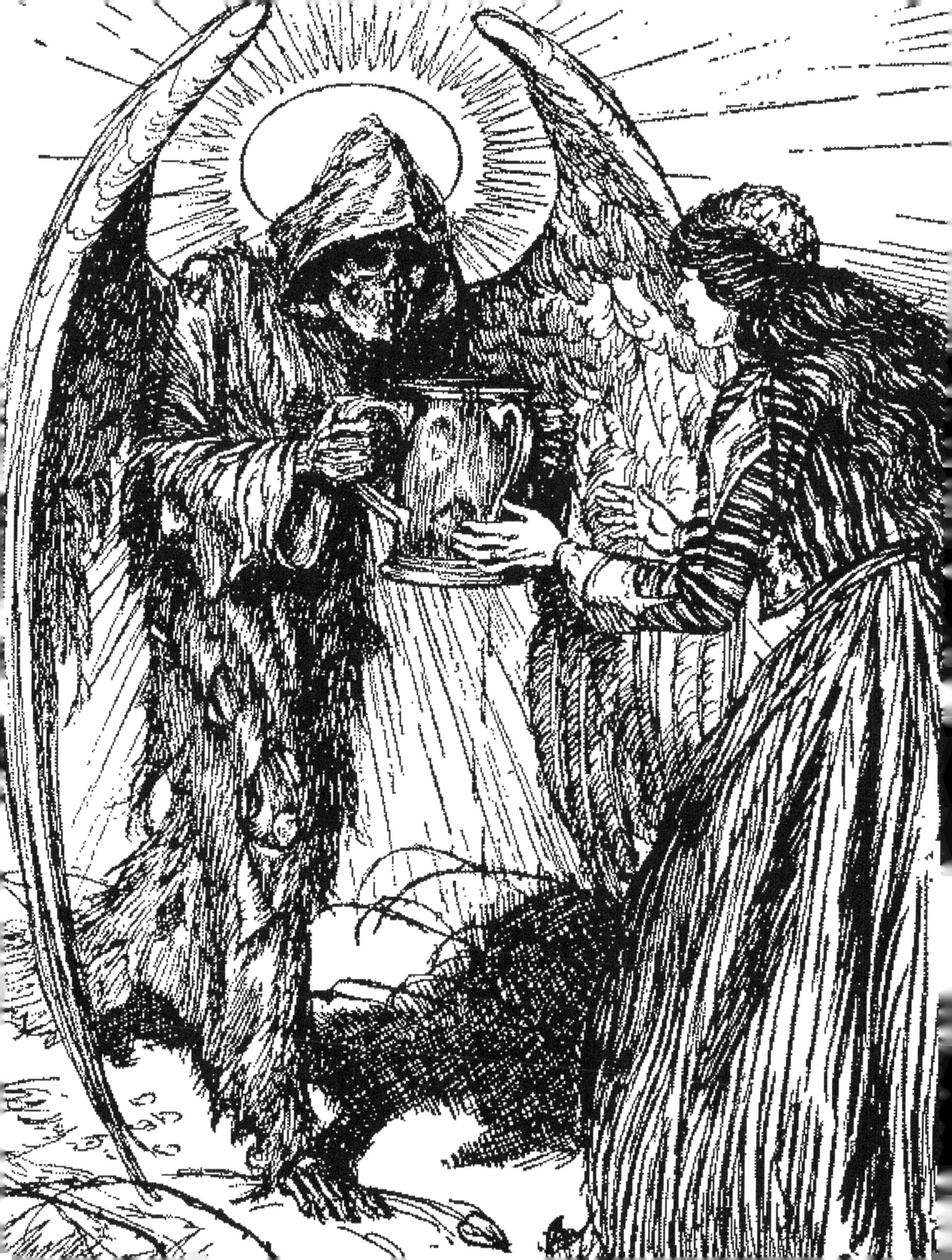

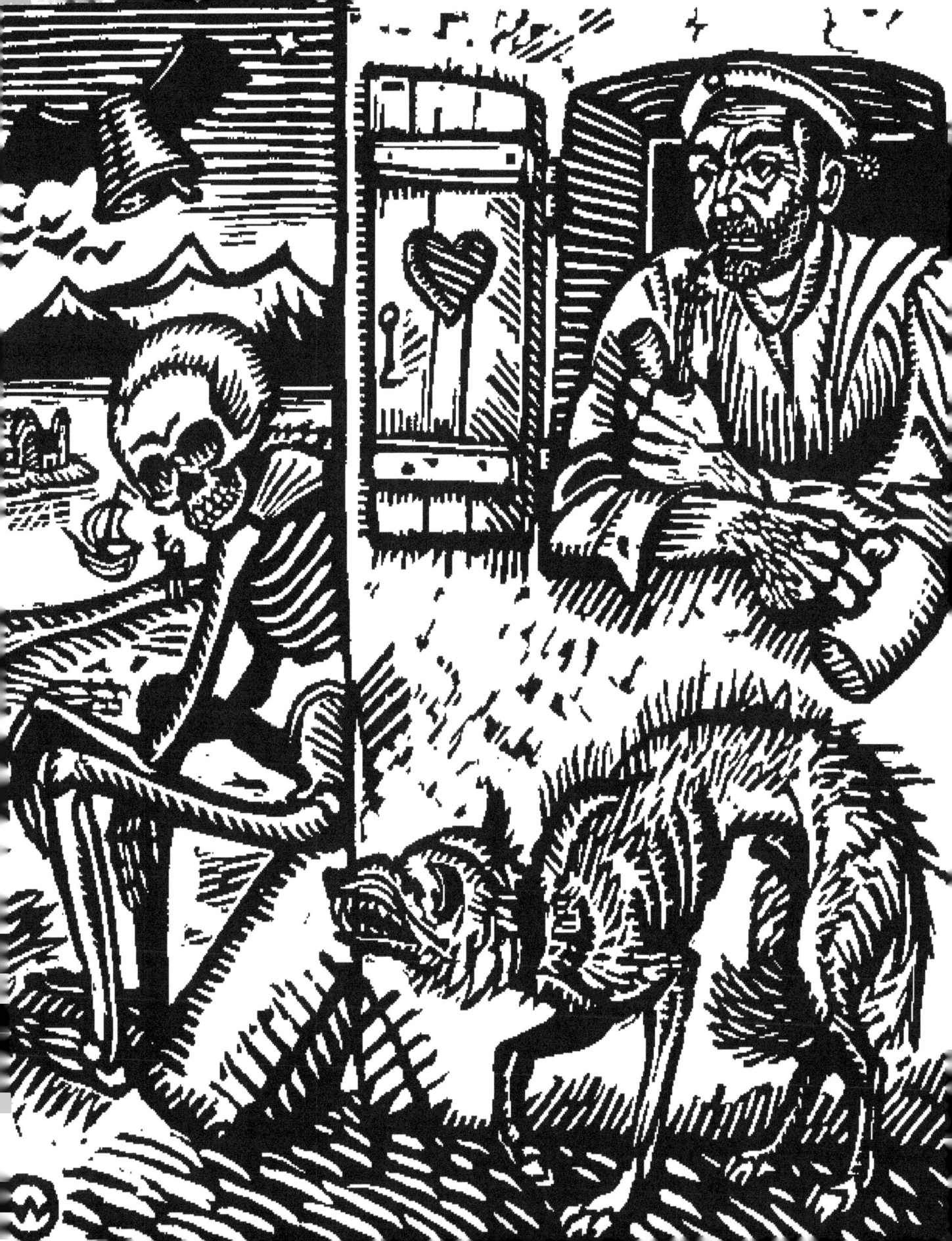

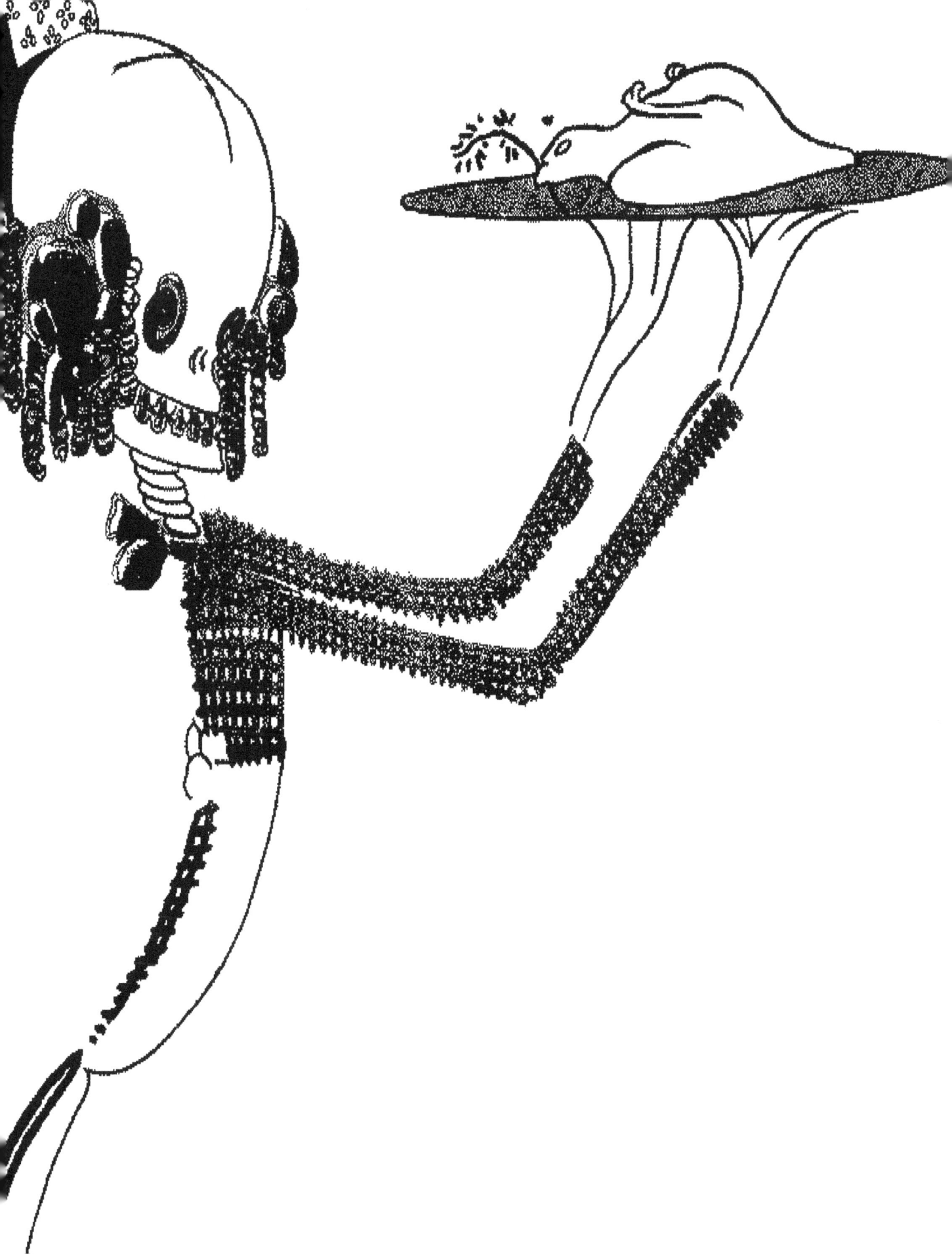

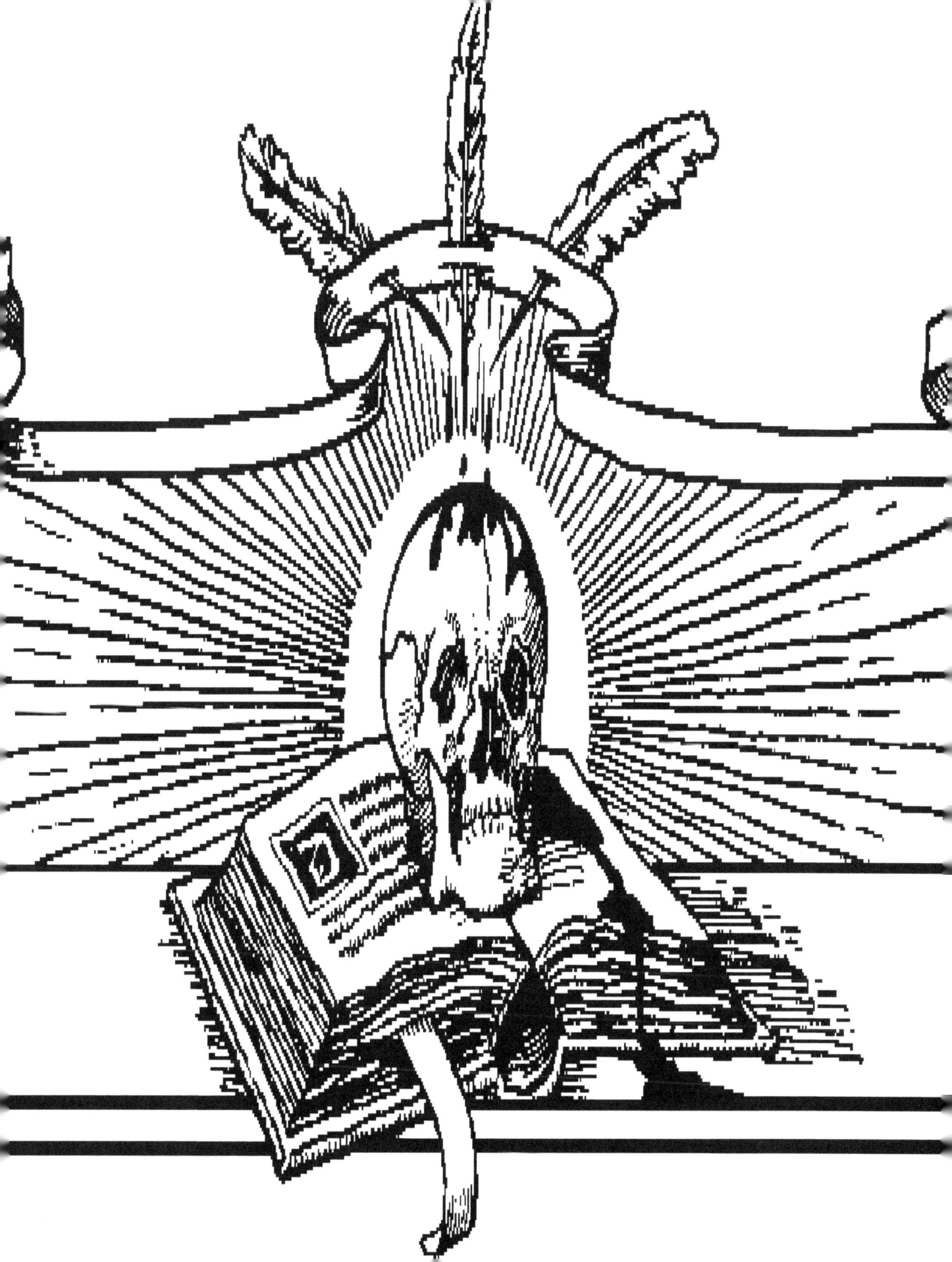

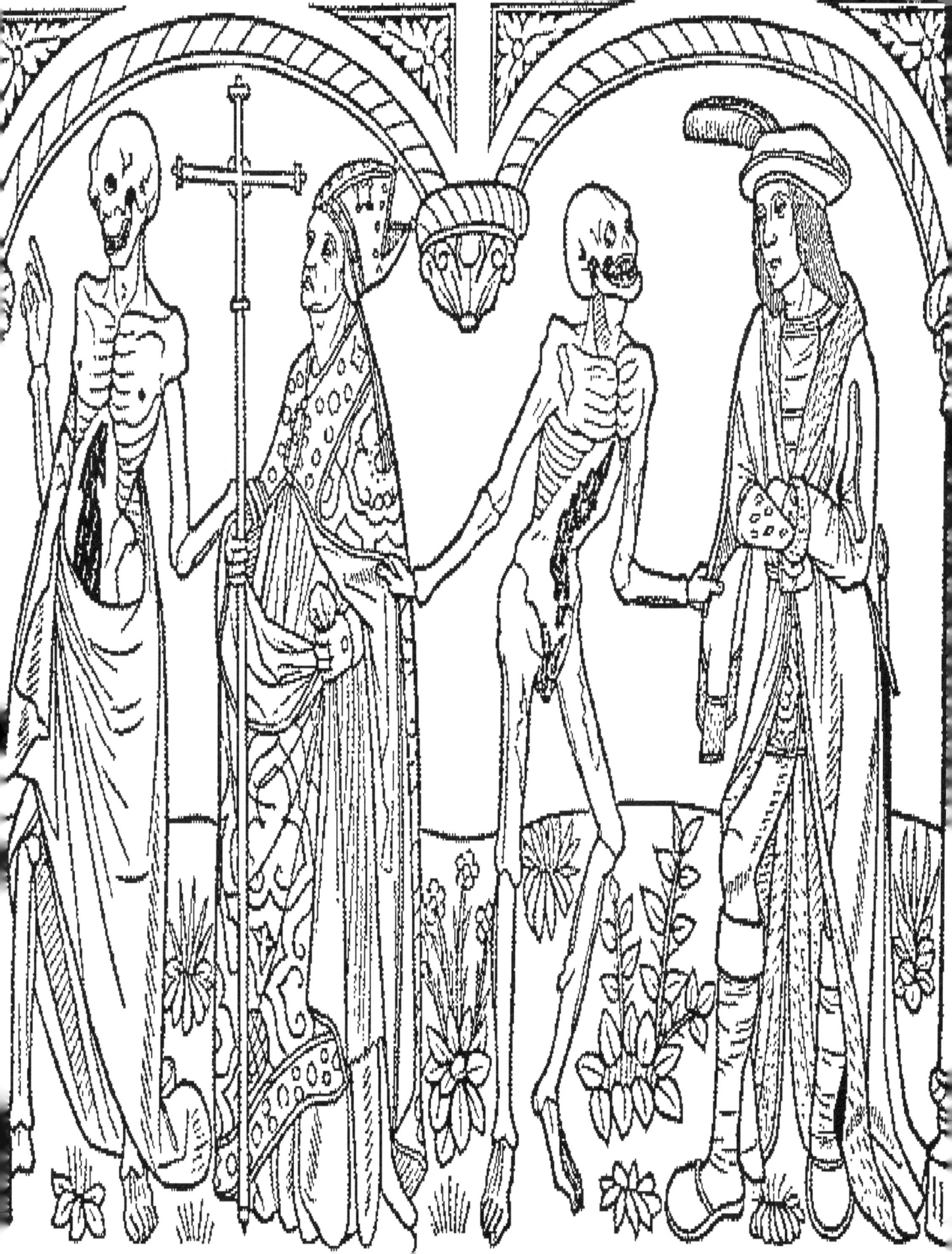

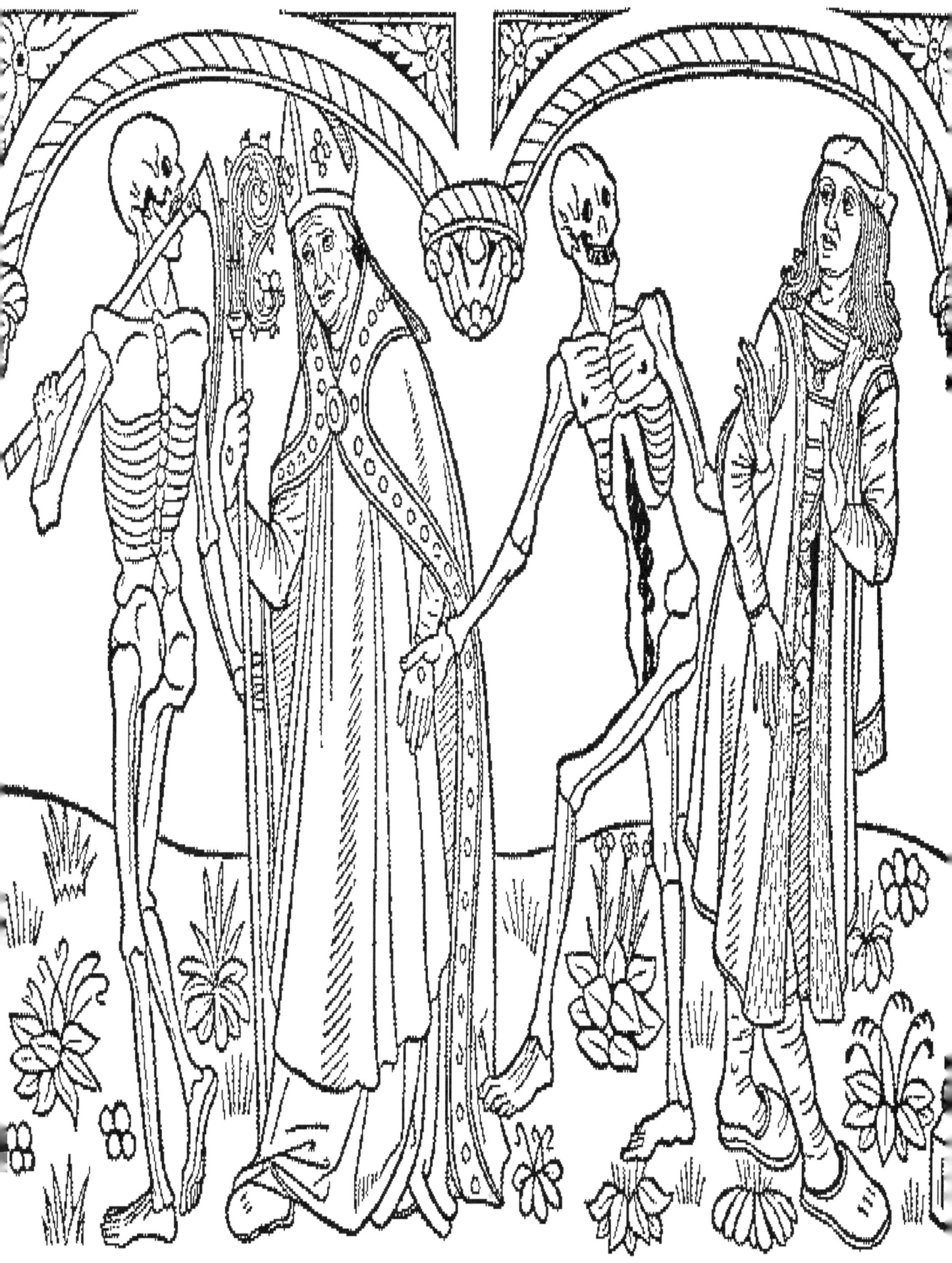

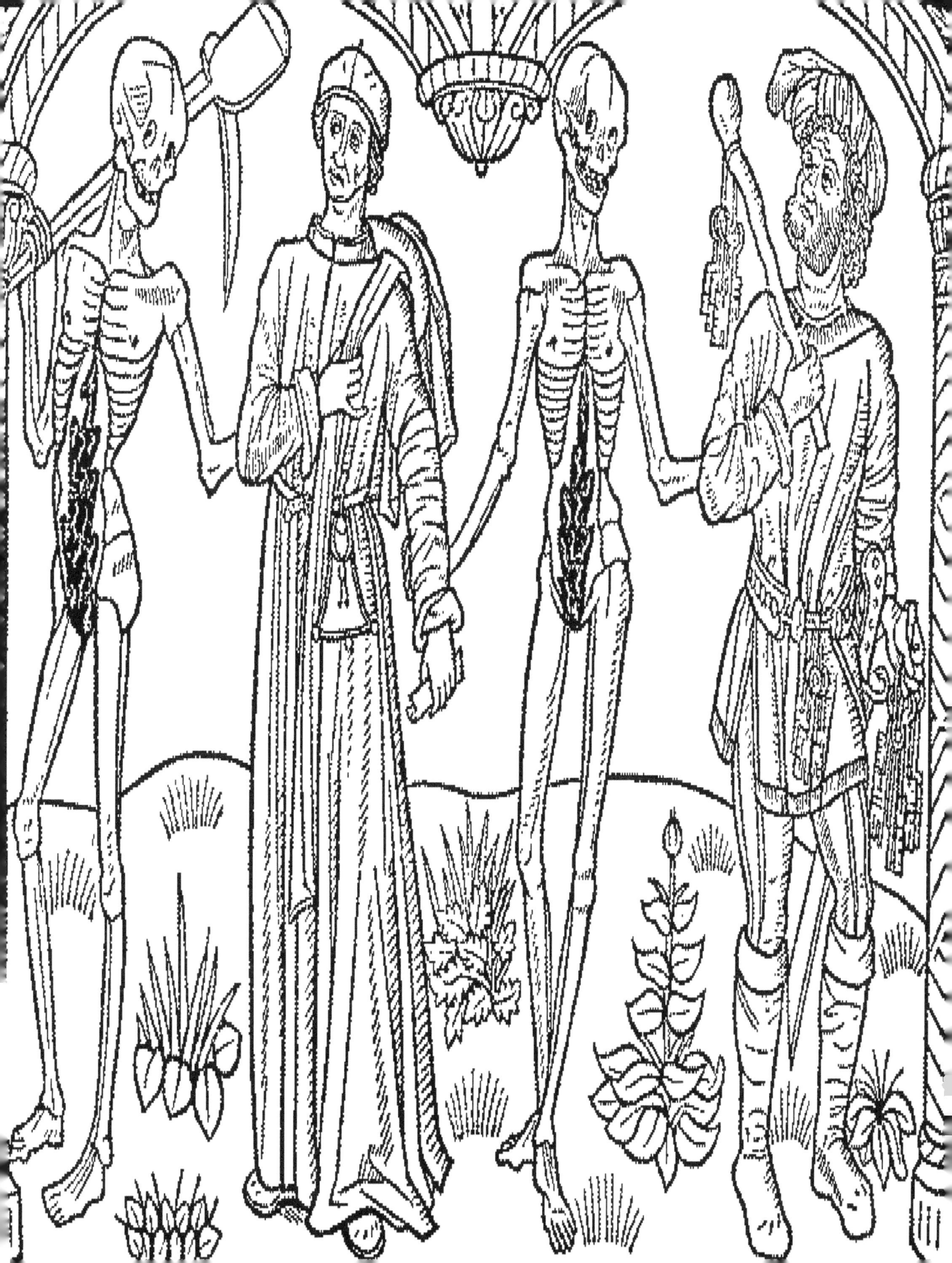

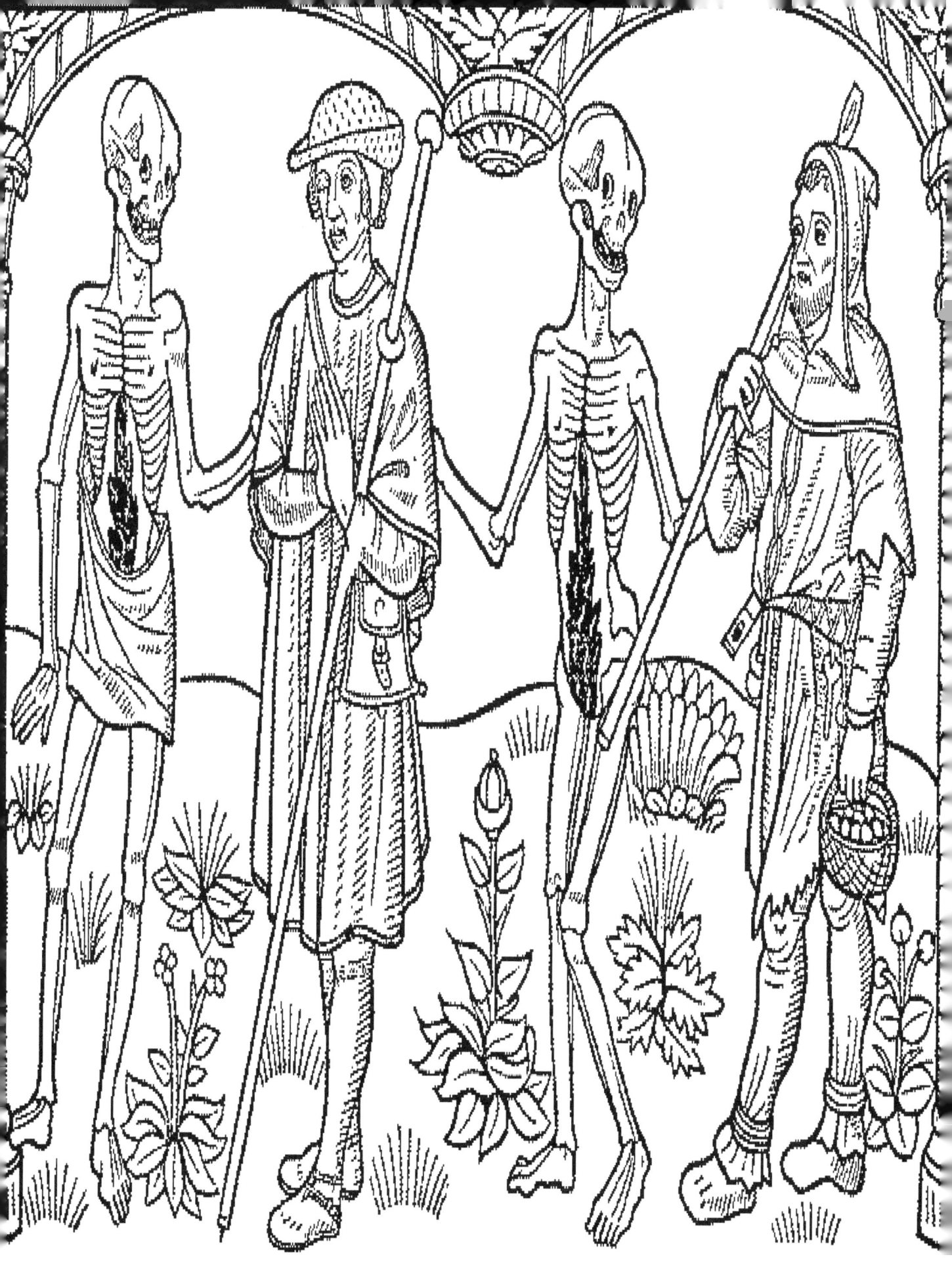

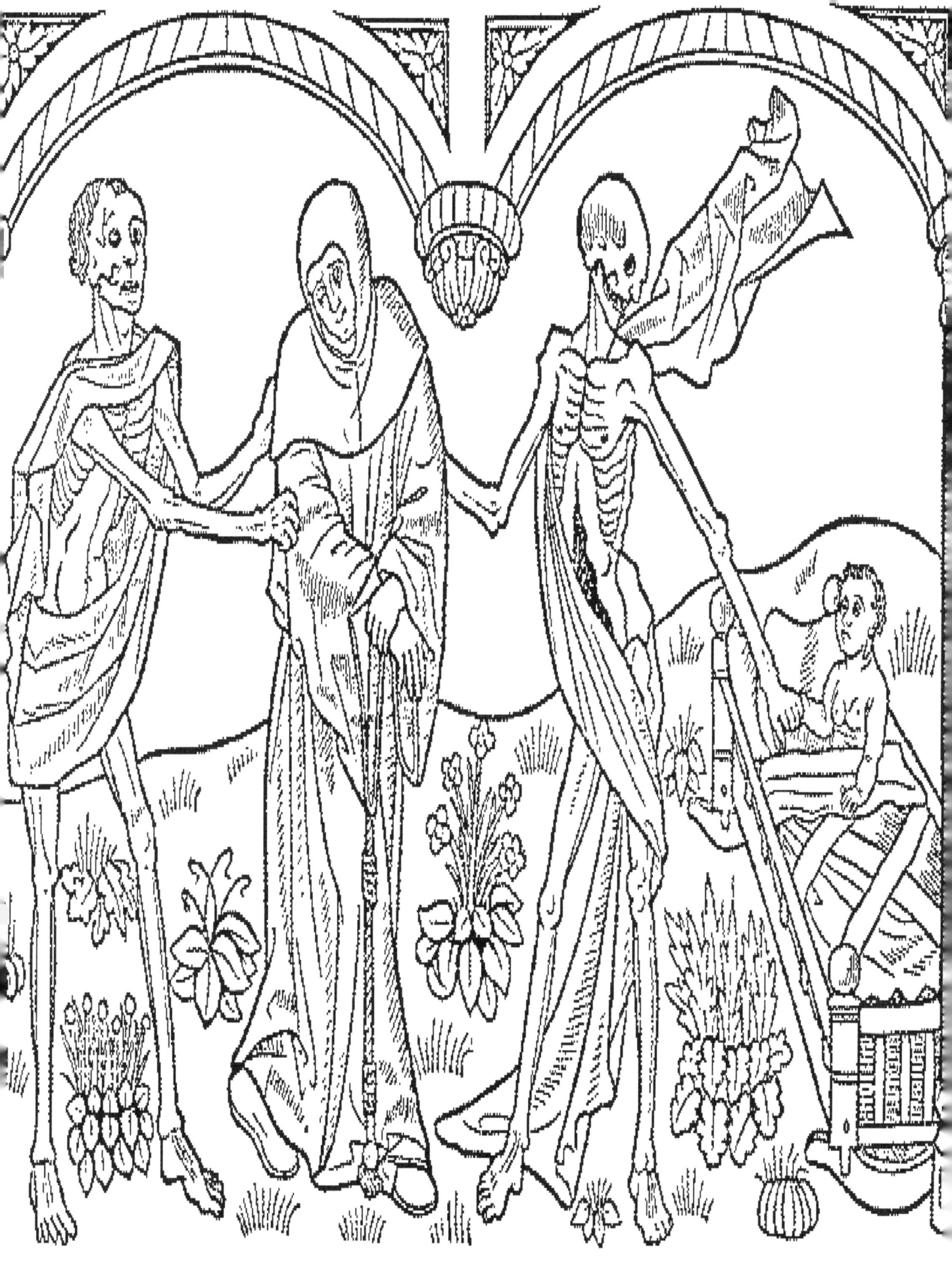

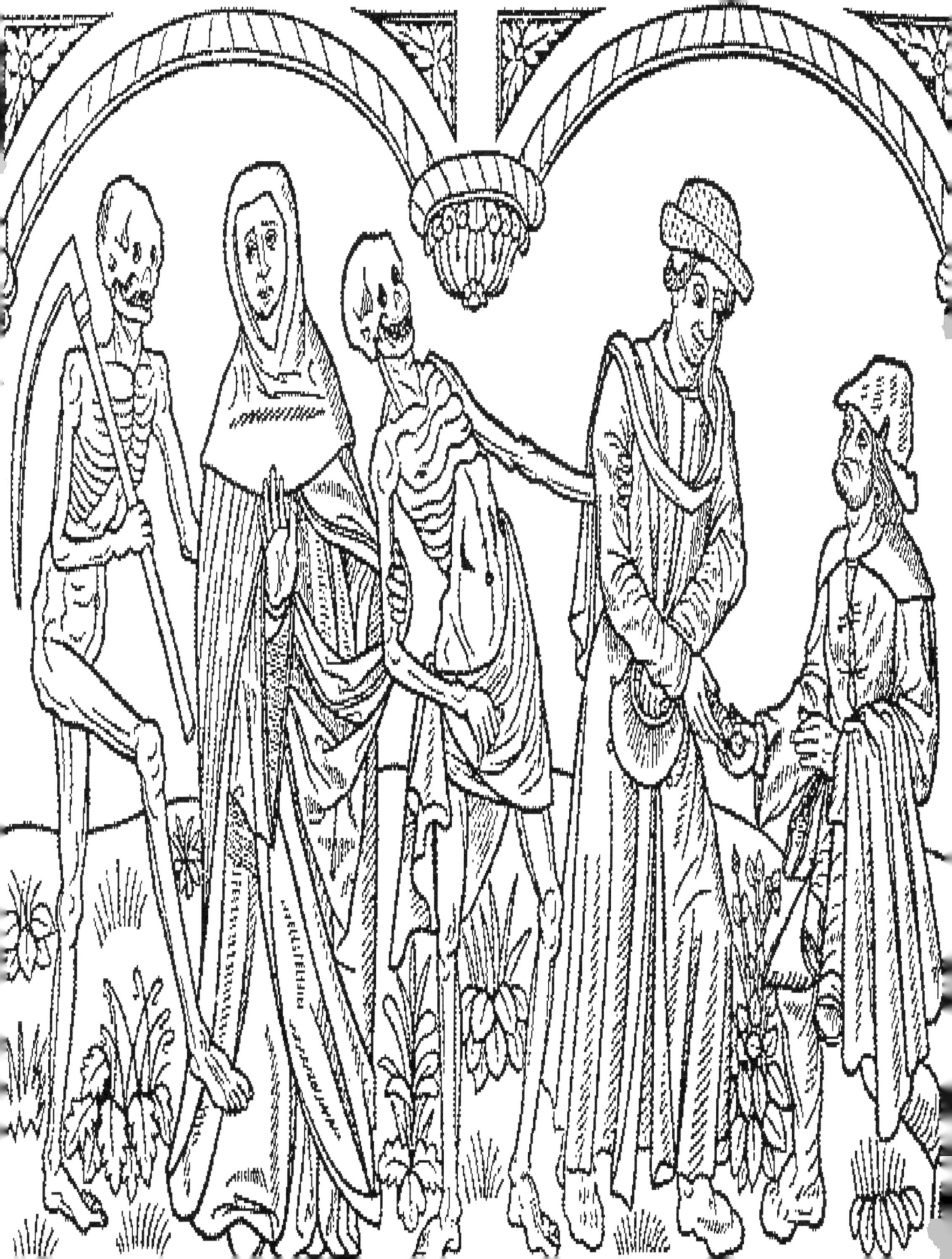

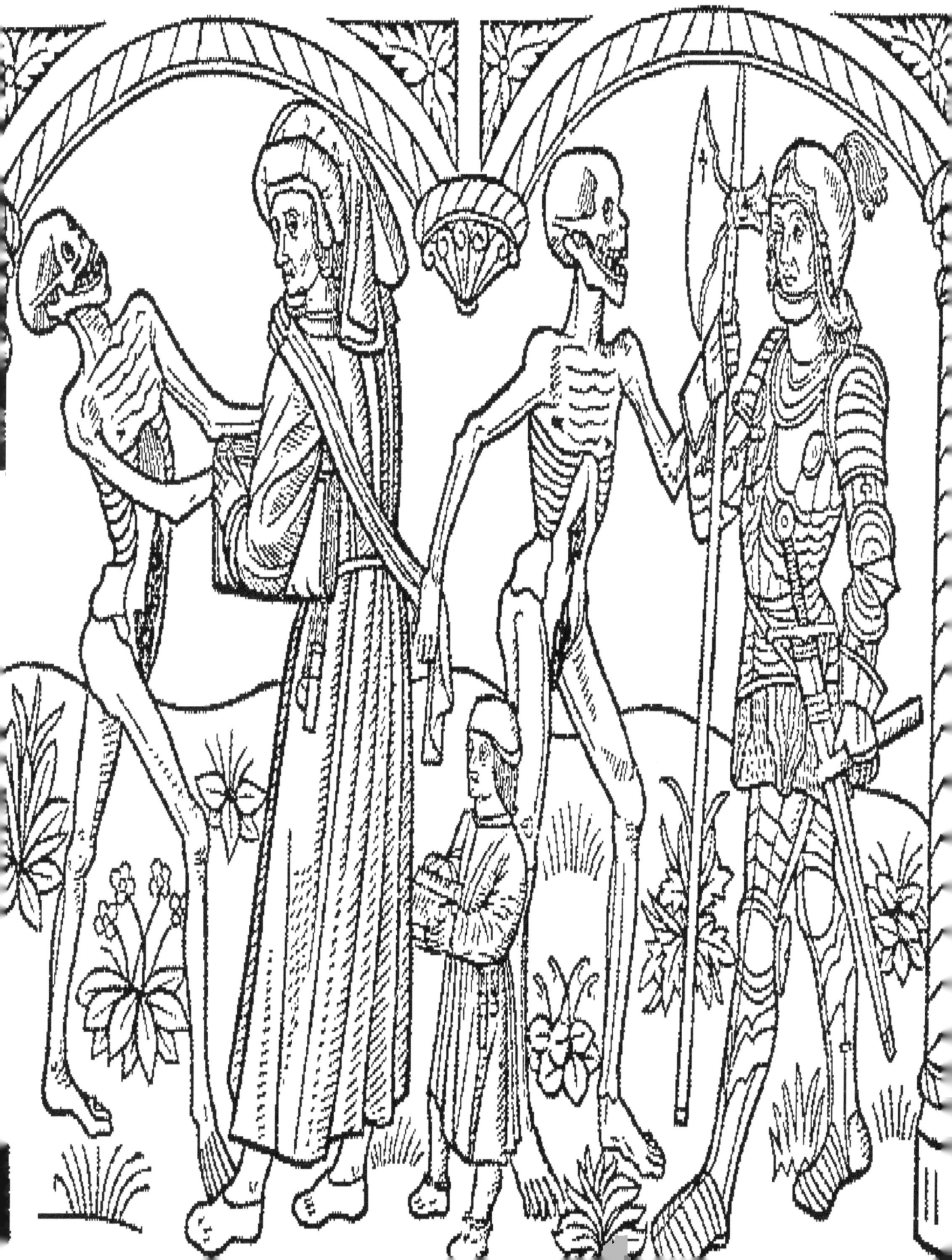

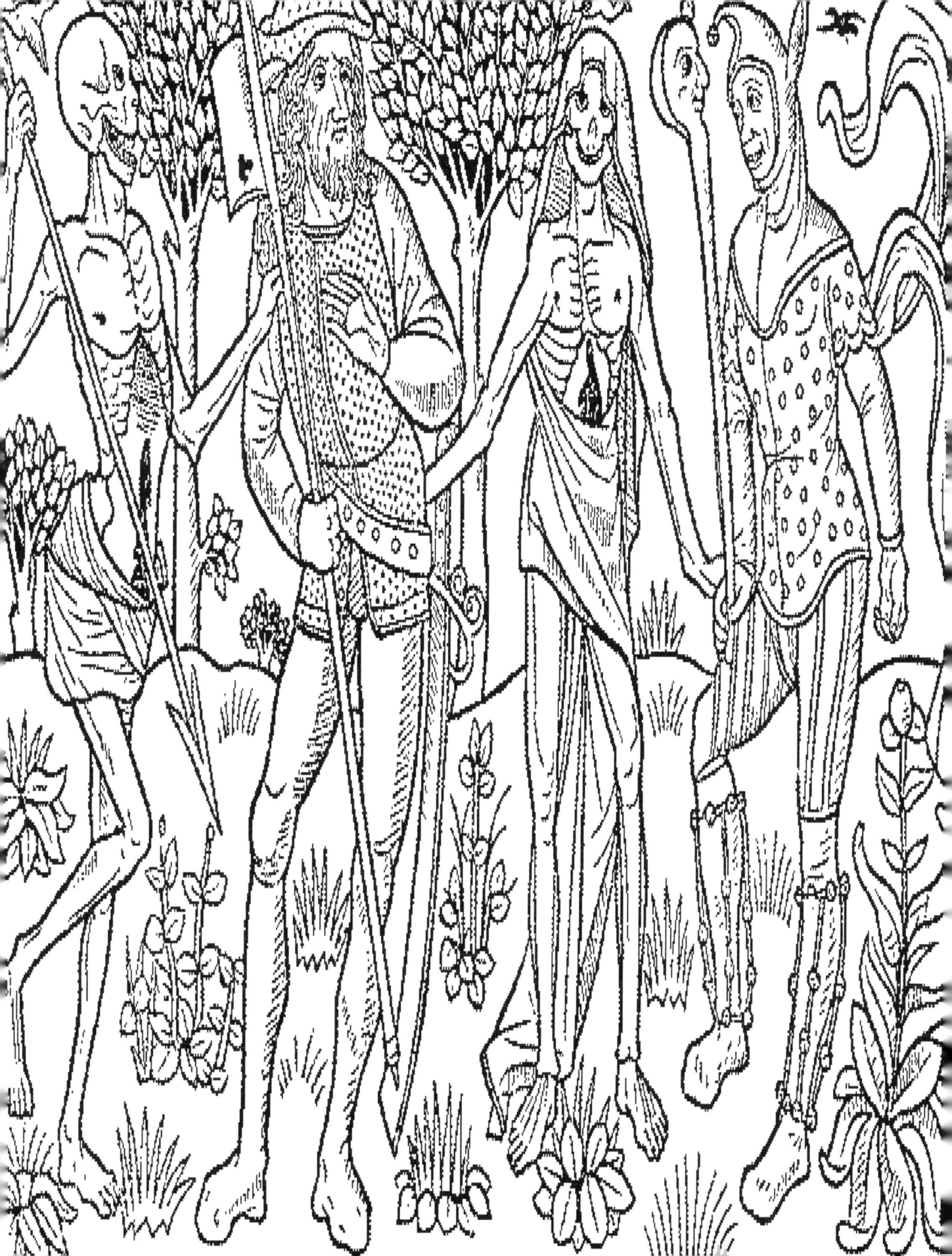

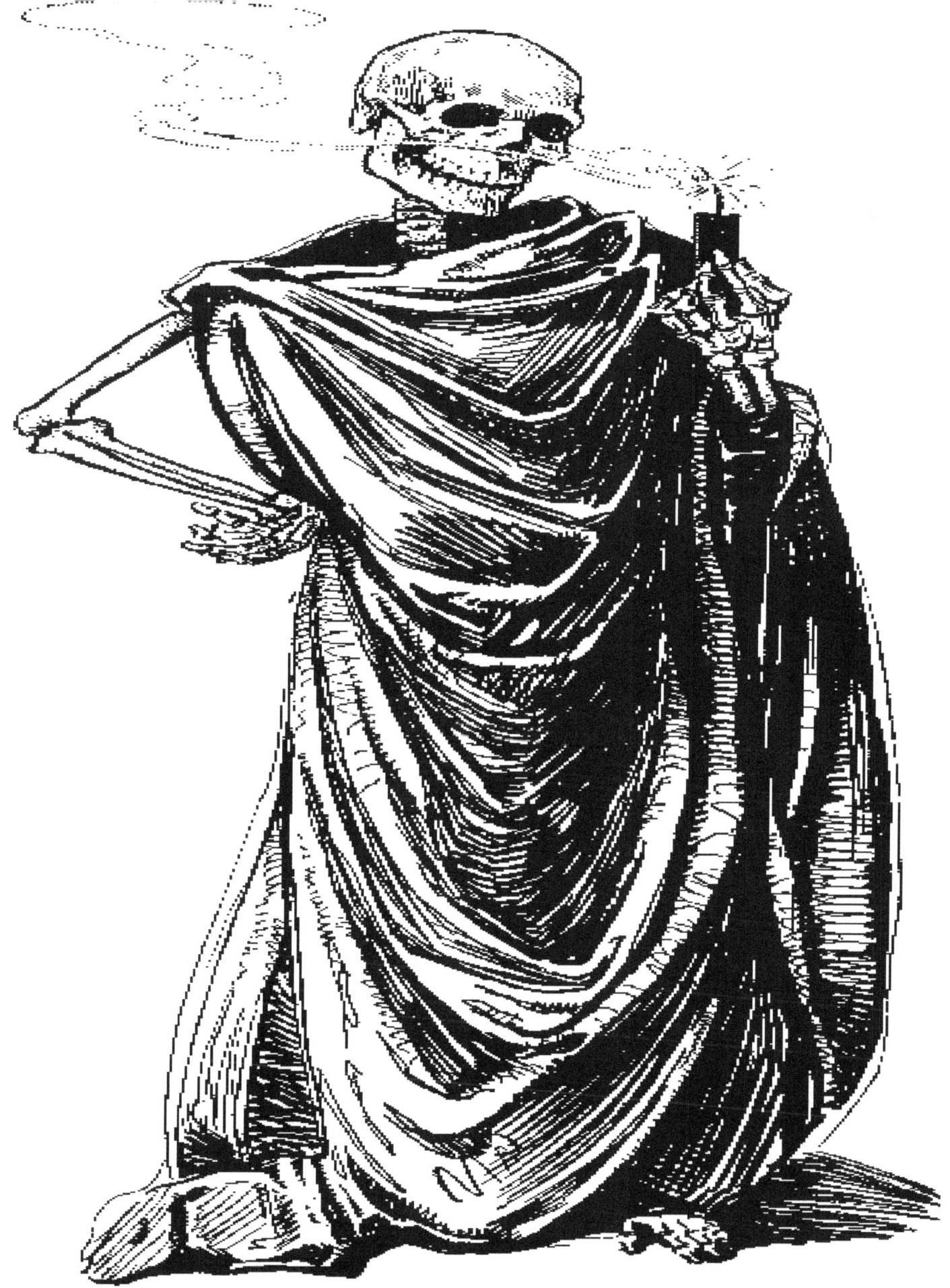

Other Coloring Books By Susan Potterfields

Epic Cat Adult Coloring Book
Epic Dog Adult Coloring Book
Epic Cow Adult Coloring Book
Epic Chicken Adult Coloring Book
Epic Dolphin Adult Coloring Book
Epic Crab Adult Coloring Book
Epic Bear Adult Coloring Book
Epic Turkey Adult Coloring Book
Epic Boar Adult Coloring Book
Epic Sheep Adult Coloring Book
Epic Rabbit Adult Coloring Book
Epic Pig Adult Coloring Book
Epic Fish Adult Coloring Book
Epic Funny Fish Adult Coloring Book
Epic Snack Adult Coloring Book
Epic Deer Adult Coloring Book
Epic Goat Adult Coloring Book
Epic Halloween Adult Coloring Book
And Many More….

DigitalColoringBooks.com

www.ingramcontent.com/pod-product-compliance
Lightning Source LLC
Chambersburg PA
CBHW080605190526
45169CB00007B/2893